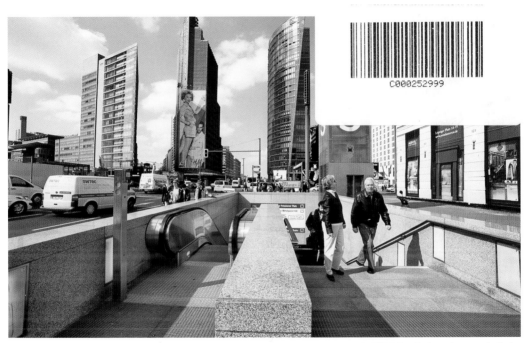

Juni 2009: Blick in die Alte Potsdamer Straße mit den Hochhäusern von Renzo Piano und Hans Kollhoff (links) sowie dem Bahn-Tower (rechts).
June 2009: View of Alte Potsdamer Straße with the high-rise buildings designed by Renzo Piano and Hans Kollhoff (left) and the Railway Tower (right).

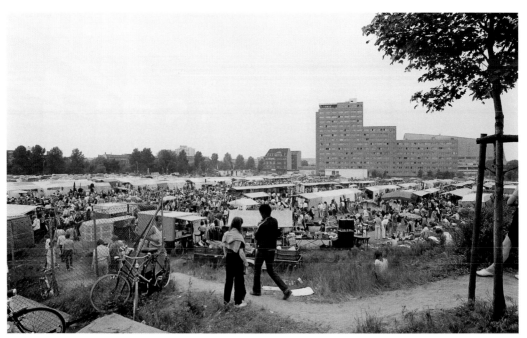

Mai 1981: Der Krempelmarkt auf den Brachflächen rund um den Potsdamer Platz; im Hintergrund der Bellevue Tower (1993 gesprengt) und dahinter die Staatsbibliothek. – May 1981: The flea market on the waste land around Potsdamer Platz; in the background is the Bellevue Tower (demolished in 1993) and behind it the State Library.

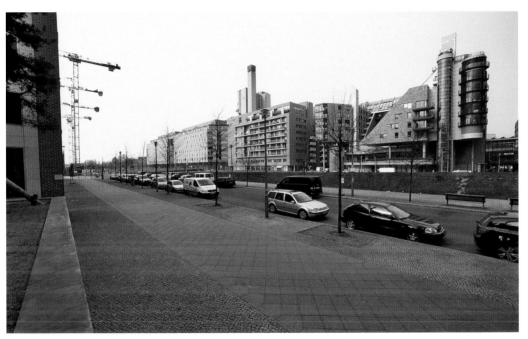

Mai 2009: Der neue Tilla-Durieux-Park entlang der Gabriele-Tergit-Promenade; im Hintergrund die Neubauten am Potsdamer Platz.
May 2009: The new Tilla Durieux Park running along Gabriele Tergit Promenade. In the background are the new buildings on Potsdamer Platz.

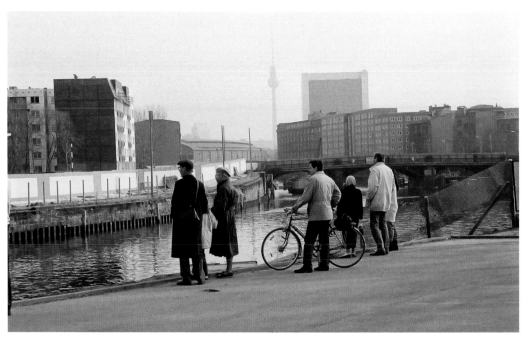

Februar 1990: Blick vom Reichstagufer in West-Berlin über die Spree Richtung Norden, damals Ost-Berlin.
February 1990: View from Reichstagufer in West Berlin looking northwards across the River Spree into what was then East Berlin.

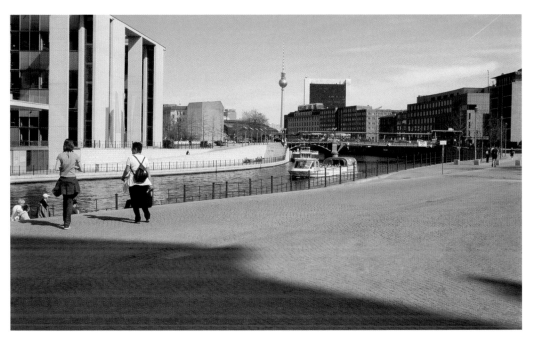

Juli 2009: Das Reichstagufer gehört heute zum Parlamentsviertel. Am Nordufer liegt das Paul-Löbe-Haus von Architekt Stephan Braunfels.
July 2009: The Reichstagufer is now part of the parliamentary precinct. On the northern bank of the river is the Paul Löbe Building designed by the architect Stephan Braunfels.

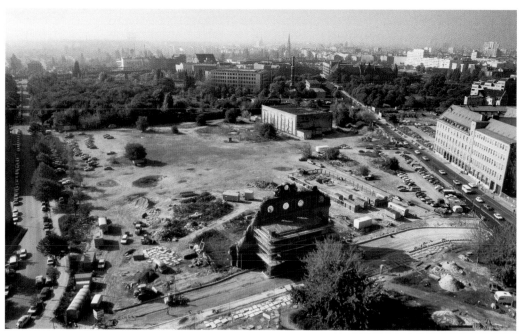

August 1983: Leerfläche zwischen Schöneberger- und Möckernstraße mit der Ruine des Anhalter Bahnhofs im Vordergrund.
August 1983: derelict area of land between Schönebergerstraße and Möckernstraße with the ruins of Anhalter Railway Station in the foreground.

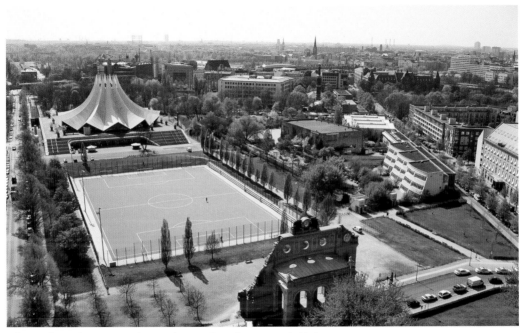

Juli 2009: Platz vor dem Konzert- und Veranstaltungsort Tempodrom von gmp Architekten.
July 2009: Square in front of the Tempodrom concert and event venue designed by gmp Architekten.

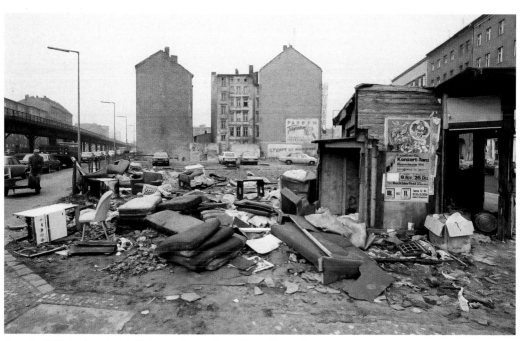

November 1980: Brache an der Ecke Skalitzer Straße/Oranienstraße in Berlin-Kreuzberg.
November 1980: Waste land on the corner of Skalitzer Straße and Oranienstraße in the district of Kreuzberg.

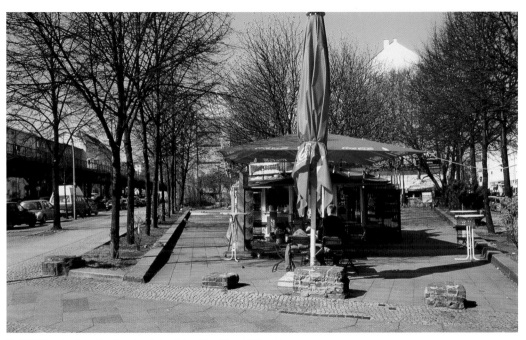

Mai 2009: Heute gibt es hier einen begrünten Platz mit Pavillon und Bäumen.
May 2009: The site has now been cleaned up and has trees surrounding a pavilion.

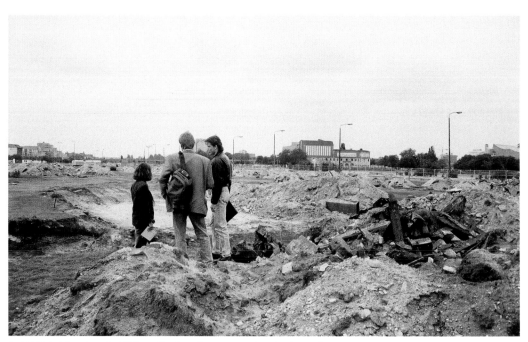

Juni 1990: Auf dem ehemaligen Todesstreifen der Berliner Mauer entlang der Ebertstraße.
June 1990: Part of the former death strip of the Berlin Wall along Ebertstraße.

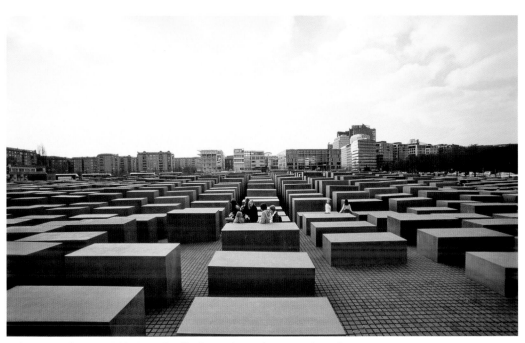

Juni 2009: Im Mai 2005 wurde hier das Denkmal für die ermordeten Juden Europas eingeweiht.
June 2009: The Memorial to the Murdered Jews of Europe was officially opened here in 2005.

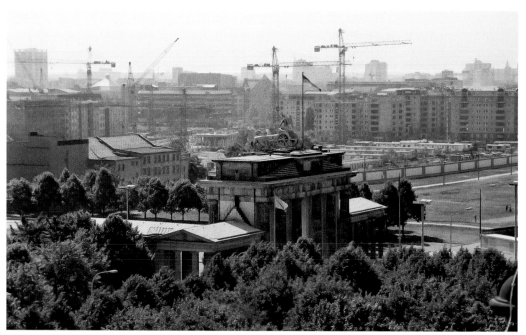

Juni 1989: Blick vom Reichstag auf das Brandenburger Tor.
June 1989: View of the Brandenburg Gate from the Reichstag.

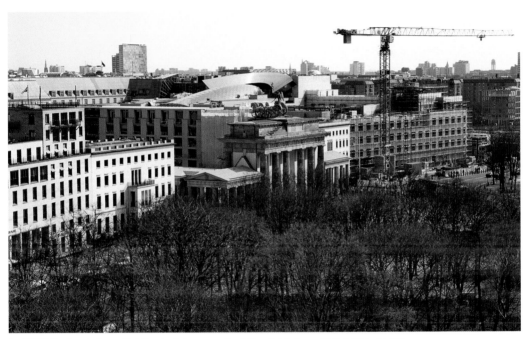

April 2007: Das Brandenburger Tor ist heute wieder von repräsentativen Gebäuden und Botschaften umgeben.
April 2007: The Brandenburg Gate is now once again surrounded by imposing buildings and embassies.

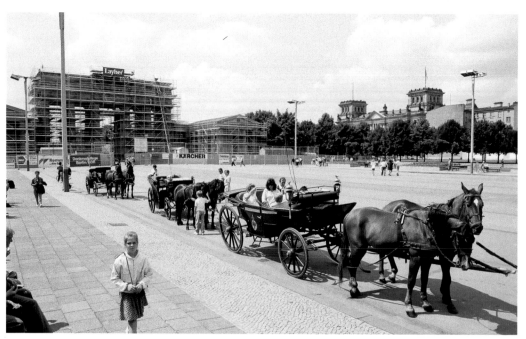

Juli 1990: Der Pariser Platz am Brandenburger Tor zu Beginn der Neubauarbeiten. Das gesamte Areal war für fast vier Jahrzehnte Niemandsland.
July 1990: Pariser Platz adjoining the Brandenburg Gate at the time reconstruction work started. The square had been part of no-man's-land for almost forty years.

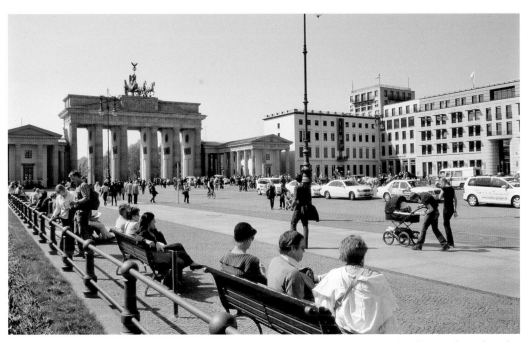

Juli 2009: Die wieder hergestellte barocke Platzanlage vor dem renovierten Brandenburger Tor gehört heute zu den schönsten Adressen der Stadt.
July 2009: The restored Baroque square in front of the renovated Brandenburg Gate is now one of the finest locations in the city.

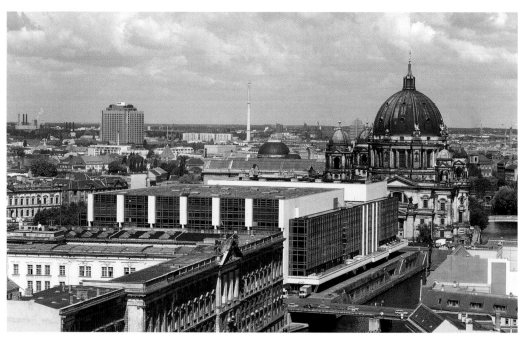

Mai 1990: Blick vom Südosten über die Spreeinsel mit Marstall, Palast der Republik und Berliner Dom.
May 1990: View from the south-east across Spree Island with the Marstall (the former Royal Stables), the Palace of the Republic and Berlin Cathedral.

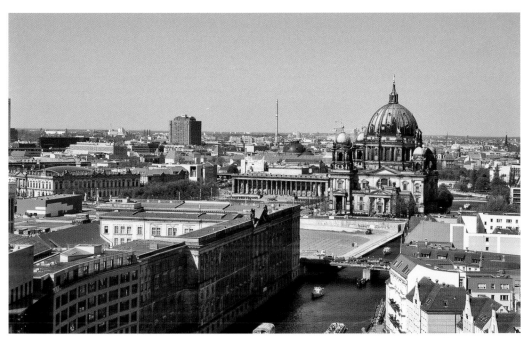

Mai 2009: Zwischen Marstall und Berliner Dom gähnt die Lücke des abgetragenen Palasts; hier soll 2010 mit den Bauarbeiten für die Rekonstruktion des Stadtschlosses begonnen werden. – May 2009: Between the Marstall and Berlin Cathedral is the large gap left by the demolition of the Palace of the Republic; work on rebuilding the former Royal Palace here is due to begin in 2010.

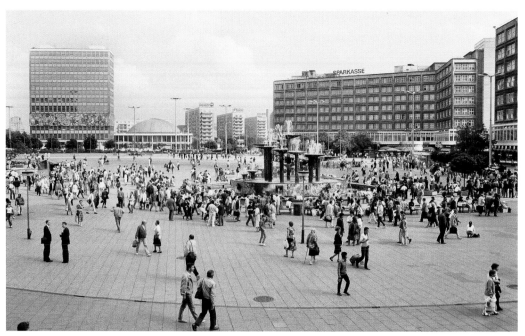

Mai 1990: Der Alexanderplatz im Zentrum des Berliner Ostens; im Hintergrund das Haus des Lehrers und die Kongresshalle mit der runden Kuppel.
May 1990: Alexanderplatz in the heart of Berlin's eastern city centre; in the background are the Teachers' Centre and the Congress Hall with its round dome.

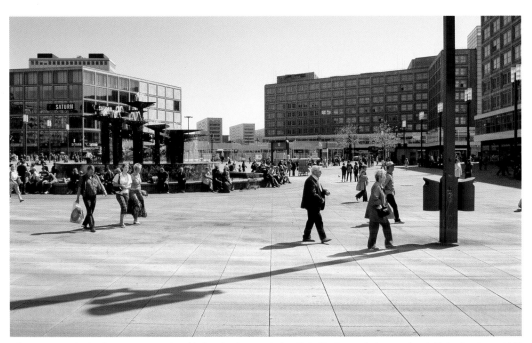

Juli 2009: Fast zwei Jahrzehnte später präsentiert sich der »Alex« kaum verändert. Einige Neubauten sind entstanden; ein Einkaufszentrum schiebt sich nun vor das Haus des Lehrers. – July 2009: Almost twenty years later the square has hardly changed. A few new buildings have been added, including a shopping centre in front of the Teachers' Centre.

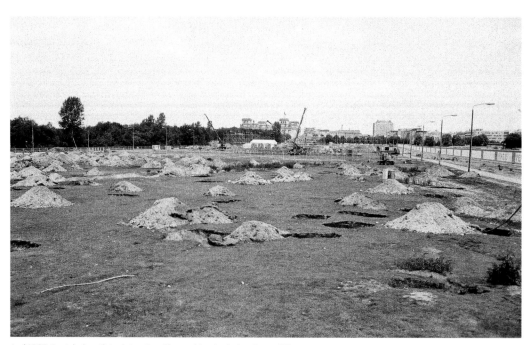

Juni 1990: Der Leipziger Platz als trauriges Niemandsland zwischen Ost und West.
June 1990: Leipziger Platz, a dismal part of the no-man's-land between East and West.

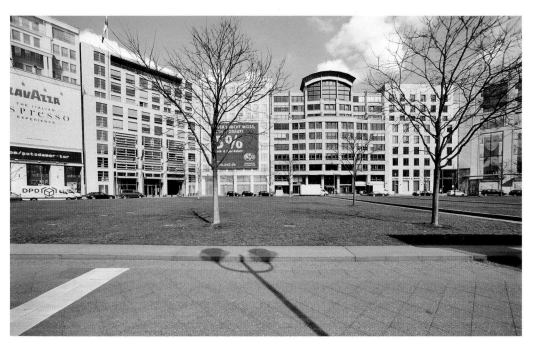

Juni 2009: Im Zuge des Wiederaufbaus wurde der ursprünglich oktogonale Leipziger Platz rekonstruiert und mit repräsentativen Wohn- und Geschäftsbauten gesäumt. – June 2009: In the meantime the octagonal square has been reconstructed and is lined with imposing residential buildings and commercial premises.

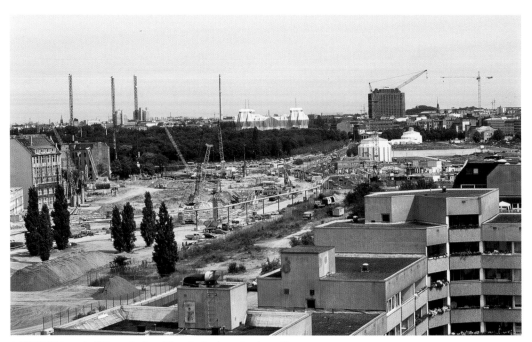

Juli 1995: Blick von der Köthener Straße auf die weite Brache am Potsdamer Platz.
July 1995: View from Köthener Straße of the large tract of derelict land at Potsdamer Platz.

Mai 2009: Das hier entstandene neue Stadtquartier mit seinen Hotels, Geschäftshäusern, Kinos und Theatern verbindet das einstmals geteilte Berlin. – May 2009: The new neighbourhood that has emerged here with its hotels, office blocks, cinemas and theatres unites the formerly divided parts of Berlin.

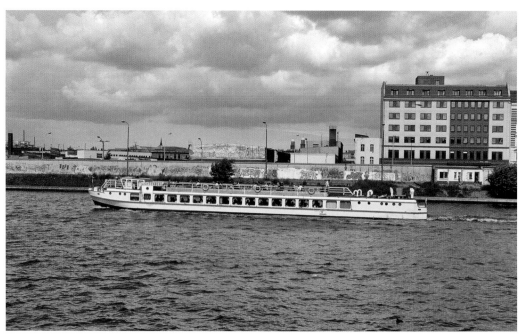

August 1991: Blick vom Gröbenufer in Berlin-Kreuzberg auf die nördliche Seite der Spree im Bezirk Friedrichshain, damals Ost-Berlin.
August 1991: View from Gröbenufer in Kreuzberg district of the northern bank of the River Spree in what was then the East Berlin district of Fried-
richshain.

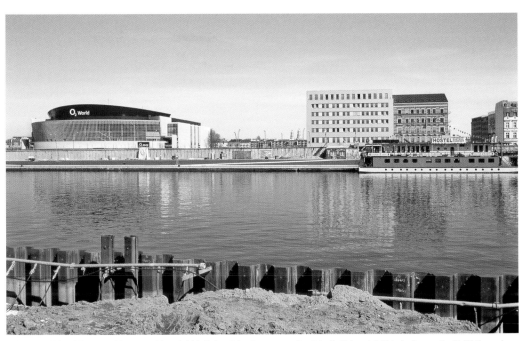

Mai 2009: Blick auf die O₂ World Arena auf der Friedrichshainer Seite. Der gesamte Bereich nördlich und südlich der Spree soll mittelfristig zu einem Medien-, Unterhaltungs- und Geschäftsstandort umgewandelt werden. – May 2009: View of the O₂ World Arena on the Friedrichshain side of the river. There are medium-term plans to transform the whole area to the north and south of the water into a media, entertainment and business location.

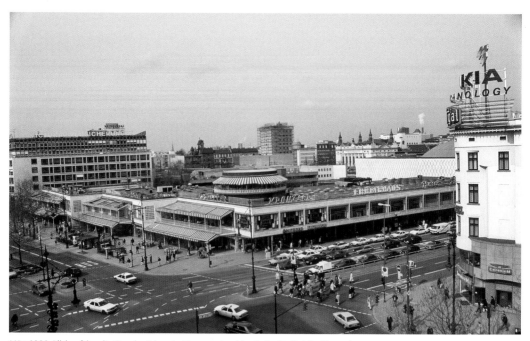

März 1989: Blick auf das alte Kranzler-Eck an der Kreuzung Joachimsthaler Straße / Kurfürstendamm.
March 1989: View of the former Kranzler-Eck café at the corner of Joachimsthaler Straße and Kurfürstendamm.

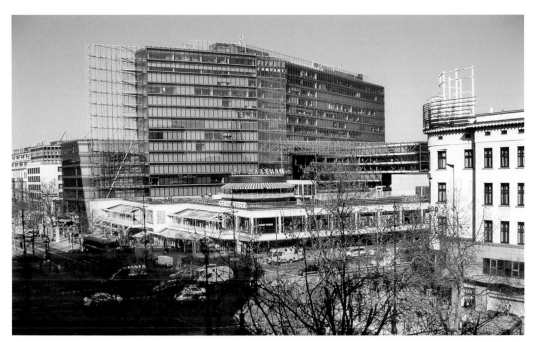

Mai 2009: Der alte Flachbau mit dem berühmten Café wurde in ein neues gläsernes Hochhausensemble des Architekten Helmut Jahn integriert.
May 2009: The old flat building with the famous café has been integrated into a new glass-and-steel high-rise ensemble designed by the architect Helmut Jahn.

29

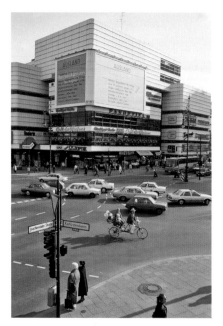 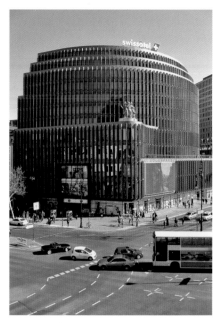

März 1989 / Mai 2009: Das Kudamm-Eck, ein Vergnügungs- und Geschäftskomplex von Architekt Werner Düttmann markierte für mehr als zwei Jahrzehnte das Dreieck Kurfürstendamm / Joachimsthaler / Augsburger Straße. Heute befindet sich an dieser Stelle ein moderner Rundbau. – March 1989 / May 2009: The Kudamm-Eck, an entertainment and commercial complex designed by the architect Werner Düttmann, stood for over twenty years at the point where Kurfürstendamm, Joachimsthaler Straße and Augsburger Straße meet. Its place has now been taken by a modern circular building.